Cover photograph: Bronze elk's head plaque from Grave VI
(see Plate XVIa)

UNIVERSITY OF OXFORD
ASHMOLEAN MUSEUM

SCYTHIAN TREASURES IN OXFORD

BY

MICHAEL VICKERS

ASHMOLEAN MUSEUM OXFORD
1979

ASHMOLEAN MUSEUM PUBLICATIONS

Archaeology, History & Classical Studies

Treasures of the Ashmolean
Ancient Cyprus
Ancient Egypt
Ancient Iran
Ancient Iraq
Ancient Italy
Archaeology, Artefacts and the Bible
The Arundel Marbles
Greek Vases

Design: author/Harley & Jones
Set in IBM Journal
Printed in Great Britain
1979

Foreword

For nearly a hundred years, the Ashmolean Museum has possessed a remarkable assemblage of Scythian grave-goods presented to Oxford University by Sir William Siemens in 1880. Other museums outside the Soviet Union may have Scythian jewellery, but the Ashmolean is alone in having more or less complete grave inventories comprising not only jewellery but also silver plate, bronzework and pottery. Some of the material is of native manufacture but much of it seems to have been made by Greek craftsmen, and we thus gain an unexpected insight into a society in transition from what had been a nomadic, steppe-dwelling existence to a civilised, urban life on the edge of the Mediterranean world. There have in the past been conflicting accounts of the discovery of the graves and the distribution of the objects found in them, but the relevant documents, which include contemporary Russian government reports and an unpublished account of the excavation made by Siemens' assistant, have never been examined together until now. But now that this has been done, it is possible to reconstruct the inventories of each burial with a fair degree of accuracy.

Thanks are due to several people who have assisted in the preparation of this little work: to Mme K. S. Gorbunova of the State Hermitage Museum, Leningrad, Academician B. A. Rybakov and Dr Y. N. Zakharuk of the Archaeological Institute of the USSR, for generously supplying copies of documents in their keeping; to Dr S. P. Boriskovskaya for advice on the Etruscan patera handle; to Dr Brian Sparkes for advice on black-glaze pottery; to Mr Brian Shefton for valuable observations on the Illyrian helmet and Castulo cups; to Dr Renate Rolle and Mlle Véronique Schiltz for their help and encouragement; to Dr Anthony Harding and Professor Elizabeth Koutaissoff for welcome assistance with translations from Russian; and to Mr John Boardman and Dr P. R. S. Moorey for kindly reading through a draft version and making helpful comments. Dr D. R. Brothwell of the British Museum (Natural History) was instrumental in the reacquisition of the skeletal material by the Ashmolean and Miss Rosemary Powers provided useful information, Dr John Peter Wild of the Department of Archaeology at Manchester University and Dr M. L. Ryder of the A.R.C. Animal Breeding Research Organisation examined the textiles, and Dr R. Reed of the Proctor Department of Food and Leather at Leeds University identified the leather. Advice on metal hardness was given by Dr J. D. E. Campbell and Mr Roger Stone of the Department of Engineering Science at Oxford University, and by Dr P. H. Blythe, of St Mary's College, Twickenham. An X-ray fluorescence examination of the surface of the helmet was conducted by Dr D. M. Metcalf. The drawings are by Mrs Pat Clarke and the photographs by Miss Olive Godwin

(with the exception of the seal and ring faces and impressions, which are the work of Mr Robert Wilkins). Mrs Jane Barlow patiently typed the manuscript.

Michael Vickers
Assistant Keeper

Introduction

In December 1868 some tumuli in the necropolis of the city of Nymphaeum were explored by a certain Franz Biller, probably illicitly and certainly destructively. Tomb-robbing had been going on since 1867, and some of the finds had been confiscated and taken to the Hermitage (M. Rostovtzeff, *Skythien und der Bosporus* [1931] 344). The rich contents of the tombs over which the tumuli had been constructed were the main object of Biller's excavations. They included armour, rings, bracelets, necklaces and pottery and were offered for sale to the Director of the Museum of Antiquities at Kerch, A. Lyutsenko, but the price (at 3,000 roubles) was considered to be too high. Lyutsenko did, however, submit a report to the Imperial Archaeological Commission in St Petersburg (Appendix III), and also published a short note in a Muscovite archaeological journal in 1870 (Appendix II). Biller had not been wholly destructive, however, and had made notes on his activities at Nymphaeum, describing the tombs and their contents in some detail (Appendix I). These notes served as the basis for the only relatively complete publication to date of the objects, made by E. A. Gardner in 1884. By this time the grave goods, or what was left of them, had been presented to the University of Oxford by Sir William Siemens, the engineer. He was in the Crimea in June and July of 1869 supervising in person the laying of part of the Indo-European Telegraph across the straits of Kerch (W. Pole, *The Life of Sir William Siemens* [1888] 177). He also had large mineral holdings in the Caucasus which required the permanent residence of his own agents in the area, and it seems that Biller was one of these, for he is referred to in a letter of 1880 from Siemens to Professor George Rolleston at Oxford as 'one of my former assistants'. Siemens seems to have been persuaded that he exported the objects legally from Russia, for in the same letter he says 'What adds to their value is the circumstance that the Russian Government have reserved the right of searching these graves to themselves and have only made an exception in my favour under exceptional circumstances'. When they first came to Oxford in 1880, the objects were displayed in the University Museum, but were all transferred (with the exception of the human skeletal material) to the Ashmolean in 1885.

Gardner's account, which is unreliable in many respects (even the site is wrong) clearly speaks of five graves: those of a warrior and four women. This information was derived from Biller. Lyutsenko's rather more careful description mentions two graves: one of a warrior and a woman and the other of a warrior. These seemingly irreconcilable facts have caused scholars in the past to dismiss one account or the other, but this negative approach has not proved very

Fig. 1 Biller's sketch of Grave I.

fruitful. If, however, all three 'primary sources' — Biller's description, and Lyutsenko's report and published note — are considered together then the true state of affairs emerges, namely that we have in Oxford the contents not of five, but of six graves, the inventories of each of which can be established with a fair degree of certainty. Of Lyutsenko's two graves one was not described by Biller at all (although its contents are in Oxford), and Gardner complicated matters by including most of its contents in his Grave I. Biller's first grave, which he took simply to be that of a warrior, is in fact Lyutsenko's grave of a warrior and a woman. A comparison of the inventories bears this out and in any case the cranium and jawbone that Biller took to be part of the same skull are in fact male and female respectively. The list of drawings by 'the painter Gross' (which are lost) accompanying Lyutsenko's report includes material from nearly all the graves, not just the two that Lyutsenko described. The least confusing way of taking account of all these facts would seem to be to divide the inventory of Grave I into two parts, (a) and (b), and to call Lyutsenko's second grave Grave VI. Gardner's thoughts on the matter will be disregarded. Taking all the primary sources as well as the objects into account we can construct a picture of the tumuli, the graves and their contents as follows:

Grave I: Warrior and woman

The grave was constructed with slabs of roughly worked local limestone and was situated in the Southeast quadrant of a tumulus twenty-four feet (7.25 m) high, about two feet (60 cm) below surrounding ground level (Fig. 1). The skeletons of a dog and a horse lay on top of the grave slabs. The grave was aligned from East to West, with the heads at the East end. There was a coffin 'of walnut' held together with wooden dowels, around the upper edge a moulding. A double burial, a male and a female, apparently laid one on top of the other. The cranium of one (Plate IIc) and the mandible of the other (Plate IId) survive.

(a) The man seems to have been a warrior, and to him can be attributed a large number of arrowheads, twenty-two bronze and one bone (Plate IIa-b), whose shafts of reeds were excavated but have not survived. It is reasonable to give to him the helmet (Plate Ia-c) which is not mentioned in any of the written accounts.

(b) The woman's goods were rather richer, and included a pair of boat-shaped earrings (Plate IIIa), a small plain electrum ring (Plate XVIIIa, Fig. 12 or 13, a necklace of eight small boxes of sheet gold with pendants in the form of beechnuts (lost), a small bronze mirror (Plate IIIb), two marble alabastra (lost), and an Attic red-figure lekythos (Plate IVa, Fig. 2). There were at least eighty-four small appliqués in the form of hares (Plate IVb-c) sewn to a garment, and there was a great deal of organic material preserved: animal skins, woollen thread, samples of which are now in Oxford (Plate Va-b), pieces of sponge and nuts.

9

Grave II: Woman

Found in a small tumulus eighteen feet (6.45 m) high, one of a row of tumuli. The grave, presumably stone-built like the last, was situated in the eastern part of the tumulus and was at surrounding ground level. A wooden coffin with 'two decorative motifs' visible on one side. The head of the deceased to the East, at the neck a necklace of gold rams' heads (Plate VIa), gold circular dress fasteners at the shoulder (Plate VId) and on the right hand a gold ring with an intaglio of a sphinx (Plate VIb, Fig. 3). The pots mentioned by Biller are probably the askoi, cups and lekanis in Plates VII-IX and Figs. 2, 4-8; one of them has a woman's name Achaxe beneath (Plate IXb).

Grave III: Woman

Found in a small tumulus lying East to West. Wooden coffin. Two silver brace-lets (Plate Xb) and a small necklace (Plate Xa).

Grave IV: Woman

Found in the Southwest quadrant of a large tumulus, some two to three feet (60-90 cm) below the surrounding ground level. Stone-built, seven feet (2.10 m) long. Wooden, undecorated coffin. A necklace (Plate XIa) on the breast and two hair ornaments at the shoulders (Plate XIc). An engraved finger ring (Plate XVIIb-c or d-e, Figs 10-11) and at least forty-nine appliqués in the form of small gold lions (Plate XIIa-b) found scattered over the body and formerly, no doubt, sewn on to a garment. A small silver vase (Plate XIIIa, Fig. 9) near the left hand and close by, a washing sponge (lost). On the right, a patera (Plate XIIIb-c) and a mirror (Plate XIIId). Outside the foot-end of the coffin were found wooden cups, two spindles and the remains of a chair (all lost).

Grave V: Woman

Found in a fairly large tumulus by the seashore. Wooden coffin, in which were a finger ring (Plate XVIIb or d, Fig. 12 or 13) and a chalcedony scaraboid (Plate XIVb-c) perhaps worn around the neck.

Grave VI: Warrior

Found in a tumulus; wooden coffin with the head at the East end. At the neck an electrum torc (Plate XVa). On the chest scale armour (Plate XVb-c) decorated with a solid bronze plaque in the form of an elk's head (Plate XVIa). On the legs bronze greaves without decoration (Plate XVIb). By the legs there was probably a corroded iron sword. There was also a bronze ladle (probably the one in Plate XVIIa) and three black-glaze pottery vessels (*not* those in

Plates VIII-IX and Figs 6-8, for Lyutsenko's account specifies two paterae and a cup with a high foot).

So much for the known grave-groups. There are some objects amongst the Scythian material in Oxford which are not accounted for or whose attribution to a grave-group is not certain on the basis of the descriptions we have. The helmet (Plate Ia-c) has been mentioned already, but it almost certainly belongs to Grave I. The glass alabastron (Plate XVIIf) is not specifically mentioned in any of the accounts; it could not be one of the 'tearflasks' mentioned in connection with Grave I, for they were reported to have been of marble and were decayed. The fine bracelets with rams' heads terminals (Plate XVIIIe) surprisingly are not connected with any of the graves in the accounts we have, although Gross made a drawing of one of them. Some rings, too, lack a precise provenance. Grave IV is said to have included an 'engraved' finger ring, but it is not clear whether it was the head of a bearded man seen from the side (Plate XVIIb-c, Fig. 10) or the head of a youth shown frontally (Plate XVIId-e, Fig. 11). There is also an extra plain gold ring. There are two in all (Plate XVIIIa-b and Figs. 12 and 13), but it is impossible to say which is which. Nor do we know to which graves the small gold mask of a woman (Plate XVIIIc) or the two circular electrum bosses (Plate XVIIId) belong.

These graves are typical of those found in the necropolis at Nymphaeum (see Silant'eva, *passim*; Gajdukevič, 289-92). Some may have been more elaborate: there was one, for instance, found in 1876 (Tumulus 24) which had the skeletons of eight horses arranged around the burial chamber, two on each side. Near the skeletons were many pieces of iron and bronze harness and trappings (Silant'eva, 68-9, fig. 37), including the stylised heads of birds and a boar, made rather after the fashion of our elk plaque in Grave VI (Plate XVIa). The wooden coffin had inlaid decoration and in it was the skeleton of a warrior. Around his skull were fifteen gold appliqués (ibid., fig. 24.4-9) rather more diverse in character than ours: a ram's head, the head of an ape, a gorgoneion, a flying eagle, a seated sphinx, etc. Around his neck was a gold torc (ibid., fig. 24.1) similar to ours (Plate XVa), and on his left hand a gold ring with a Greco-Persian scaraboid (ibid, fig. 24.2, cf. Plate XIVb-c). Outside the sarcophagus there was iron and bronze armour including iron swords, daggers and spearheads. There were in addition a fragmentary silver phiale (ibid., 58, fig. 26; cf. our silver cup, Plate XIIIa), two Attic black glaze cups (Silant'eva, 60-61, figs. 28-29) and a red-figure skyphos (ibid., 59, fig. 27). These objects, as well as the bronze mirror, ladle and sieve (ibid., 65-7, figs. 34-36) are all familiar from the contents of our grave groups, but we have nothing to match the Greek bronze candelabrum surmounted by an Ionic column and a statuette of a young athlete (ibid., 62-3). For all its wealth this grave serves to show how representative the inventories of the Ashmolean grave-groups are. Like them, it shows how a Scythian of some wealth has acquired a taste for Greek fashions while continuing to possess his own native artefacts. It has also been established

beyond any reasonable doubt that the necropolis in which all these graves were found was that of the city of Nymphaeum itself, which implies that the Greek colonists and the native Scythians had achieved a high degree of assimilation.

But who were the Scythians, and what were Greeks doing in Nymphaeum at all? The Scythians seem to have had their own origins as nomads in Central Asia, but by classical times they had moved into the steppes to the north of the Crimea and occupied the area roughly between Kiev on the Dnieper in the West and the Kuban region in the East. Their distinctive 'animal style' art is of a kind which is widespread in Central Asia as far east as Kazakhstan and Siberia, but on coming into contact first with the civilisations of the Near East and then the Greek world, they adopted motifs from these areas and by the fifth and fourth centuries B.C. seem to have Greek craftsmen working for them. There were Greek settlements on the north shores of the Black Sea from the later seventh century B.C. onwards, the colonists being attracted by the rich supplies of grain, cattle and salt fish that were available in the area. Nymphaeum was just one of these settlements, founded from Miletus in the mid-sixth century B.C. on the site of a Milesian trading post (Danoff). The Scythians provided the produce which was sent to mainland Greece and the Greek colonies in Asia Minor, and in exchange the Greeks supplied the Scythians with luxury articles, often far more elaborate than those we have been discussing. These might include weapons, vessels of both metal and pottery, and jewellery.

A stunning example of the latter was discovered in 1971 in a tumulus at Tolstaya mogila in the Ukraine (*Bulletin*, pls. 31-33, no. 171; *Or des Scythes*, no. 70) in the form of a crescent-shaped gold pectoral, rather more than a kilo in weight, with three zones of ornament, the central one largely floral, but the inner and outer zones adorned with numerous small figures. In the outer zone are scenes of animals in combat, griffins attacking horses in the centre and panthers and lions attacking a stag and a boar on either side. The creatures then diminish in size through hounds and hares to pairs of grasshoppers in the corners. The inner zone is, if anything, even more interesting, for it gives us an insight into the life of Scythian nomads that is lacking even in Herodotus's vivid account (Bk IV, 1-143). Here we see Scythians 'at home': sewing a shirt, and tending their animals: horses, cattle, sheep, goats, a pig, and a couple of birds. Great prominence is given to horses in this masterpiece of the jeweller's art, but this is what we might expect given the Scythians' dependence on horses for transport, milk (and koumiss), and food. We might remember the skeleton of a horse found in the tumulus in which our Grave I was situated, or the eight horses in the grander burial described above. They would have been slaughtered at the funeral, and Herodotus tells us that as many as fifty horses — and their riders — might be killed at a royal funeral. Our grave goods are less distinguished, but are treasures all the same; both for the intrinsic value of some of the pieces of jewellery, and because of what they can tell us about the Scythian way of life.

Scythian Treasures

Map and Plates

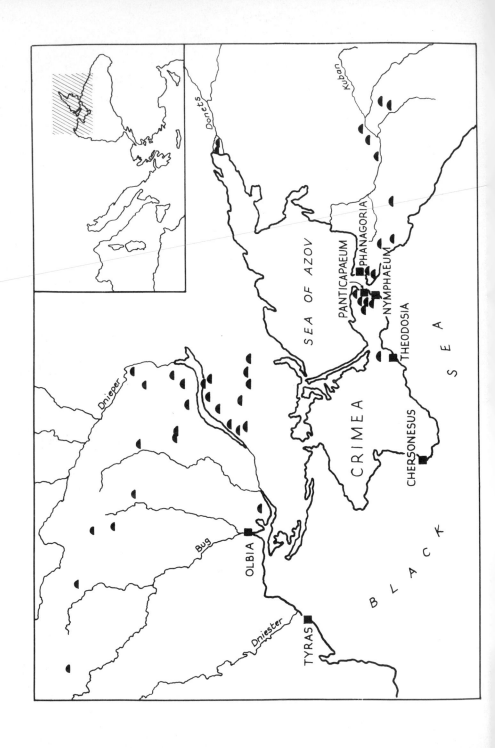

Plate I

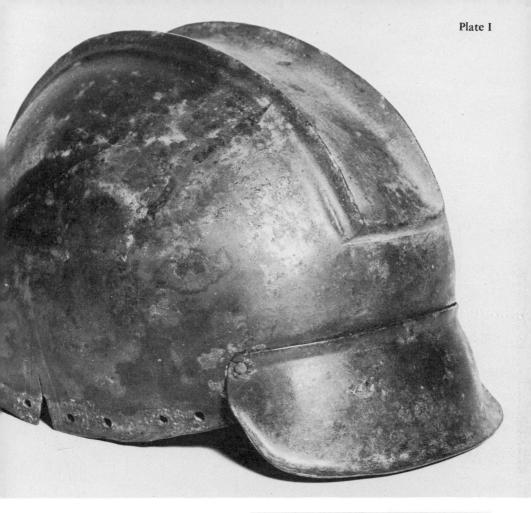

a-c. Helmet probably from Grave I(a).

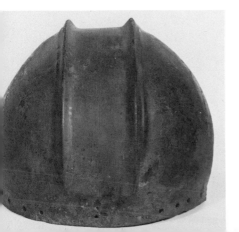

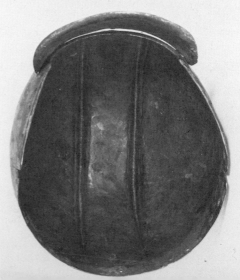

Plate II

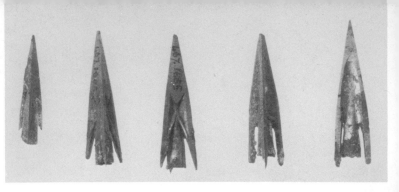

a-b. Arrowheads from Grave I(a).

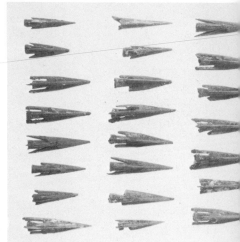

c. Cranium from Grave I(a).

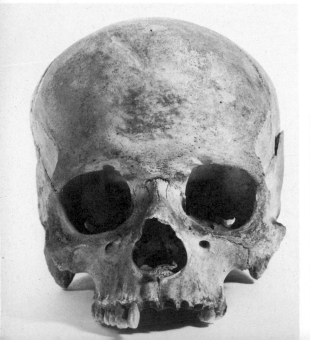

d. Mandible from Grave I(b).

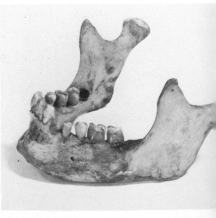

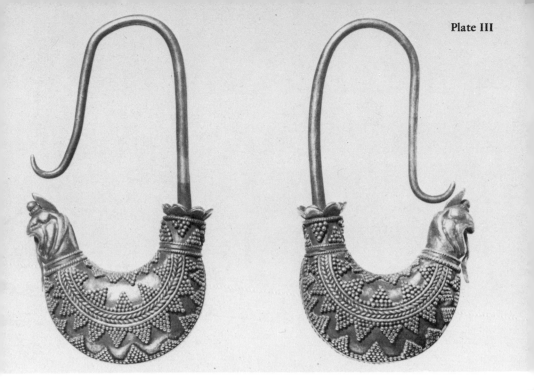

Plate III

Earrings from
Grave I(b).

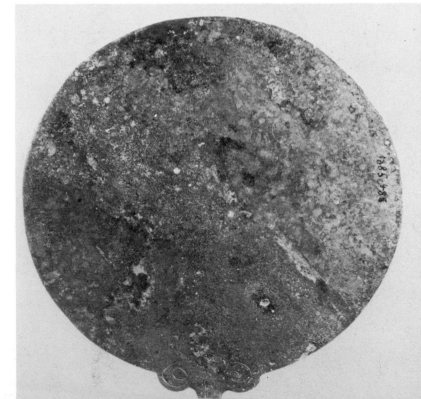

Bronze mirror
from Grave I(b).

Plate IV

a. Attic lekythos from Grave I(b).

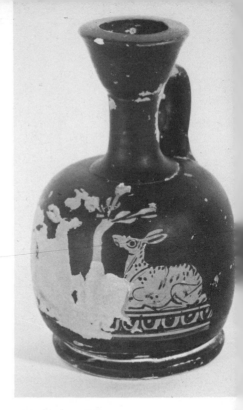

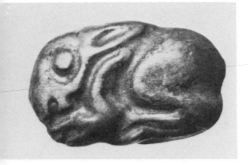

b-c. Gold hare appliqués from
Grave I(b).

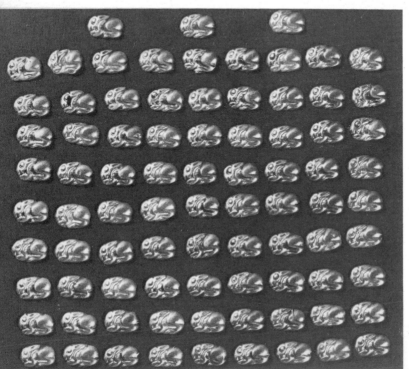

Plate V

a-b. Textile fragments from
Grave I(b).

Plate VI

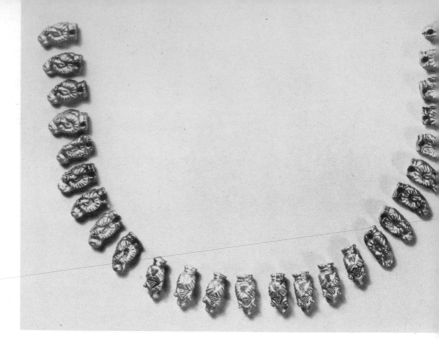

a. Gold necklace from Grave II.

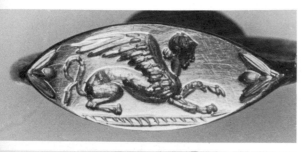

b-c. Gold ring from Grave II.

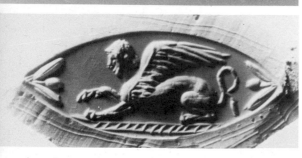

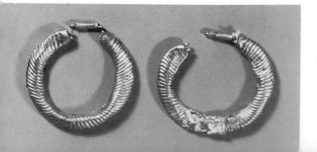

d. Gold dress fasteners from Grave II.

Plate VII

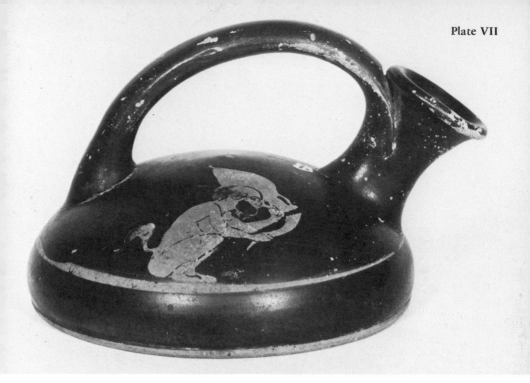

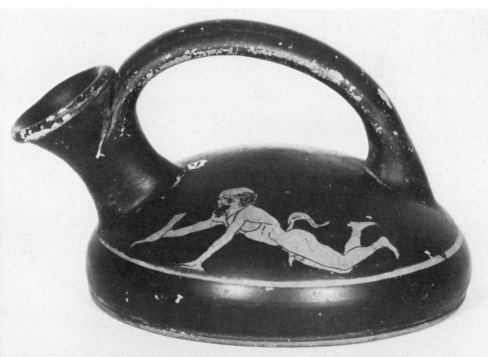

a-b. Attic askos from Grave II.

Plate VIII

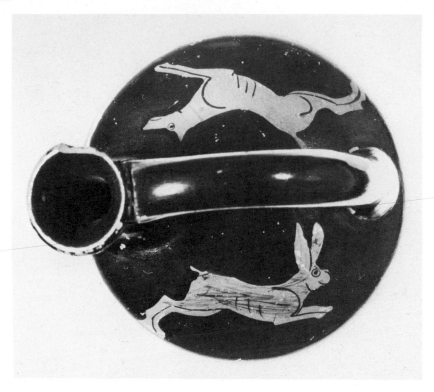

a. Attic askos from Grave II.

b. Attic cup-skyphos from Grave II.

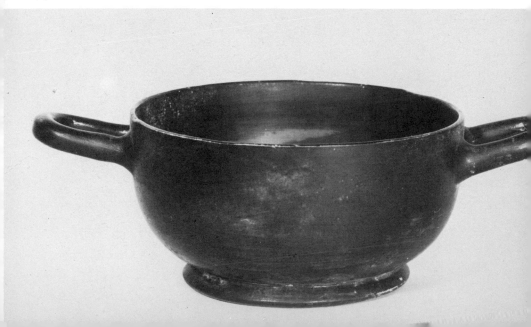

Plate IX

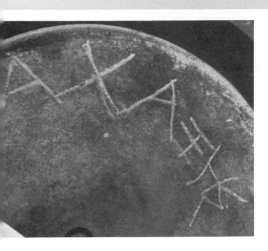

a-b. Attic stemless cup from Grave II.

c. Attic lekanis from Grave II.

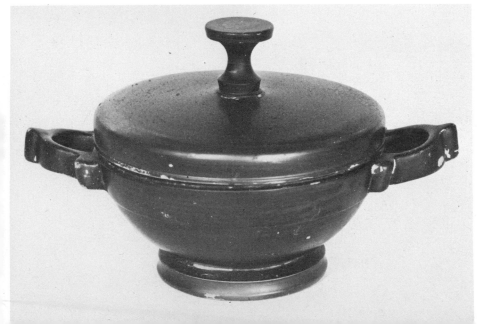

Plate X

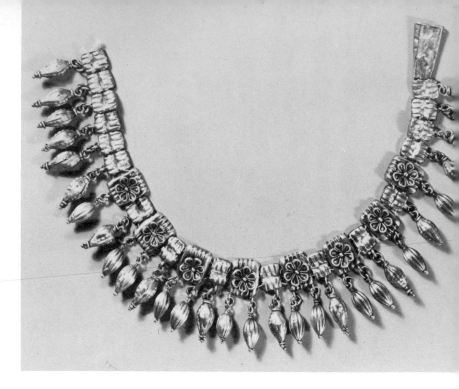

a. Electrum necklace from Grave III.

b. Silver and electrum bracelets from Grave III.

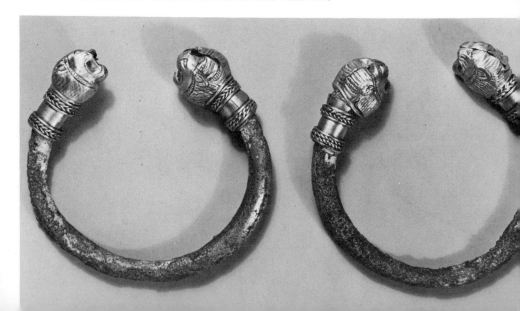

Plate XI

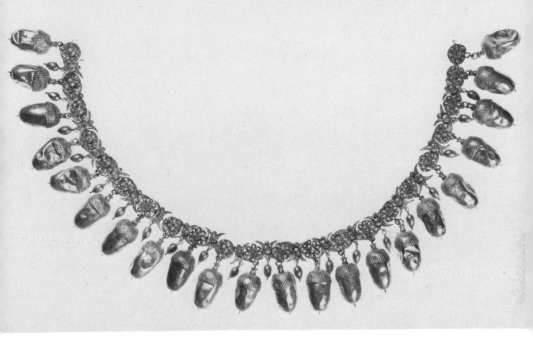

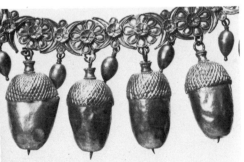

a-b. Gold necklace from Grave IV.

c. Hair ornaments from Grave IV.

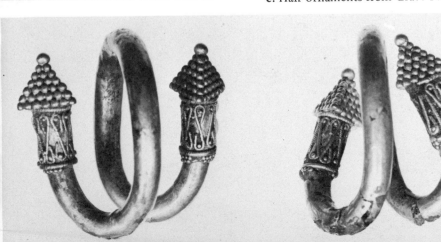

Plate XII

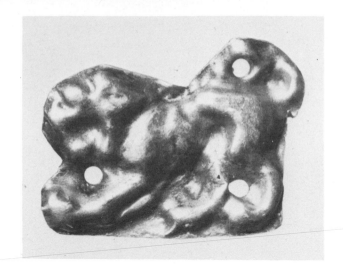

a-b. Gold lion appliqués from Grave IV.

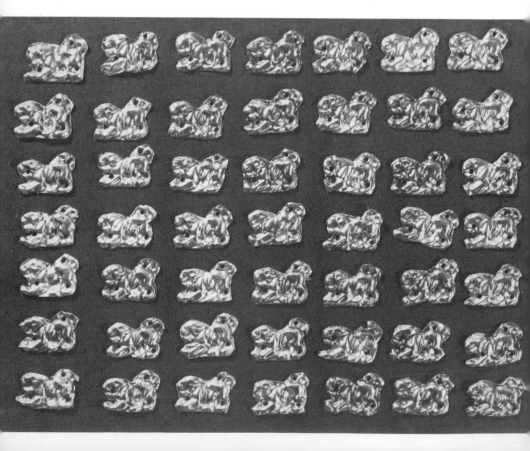

Plate XIII

a. Silver cup from Grave IV.

b-c. Bronze patera handle from Grave IV.

d. Bronze mirror disc from Grave IV.

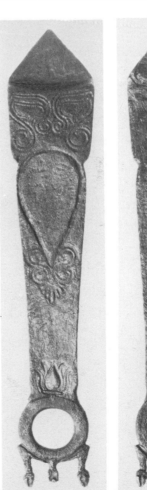

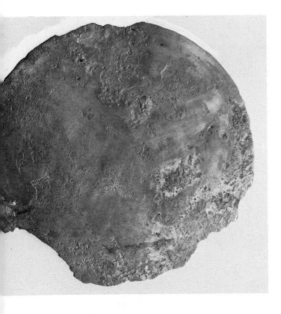

Plate XIV

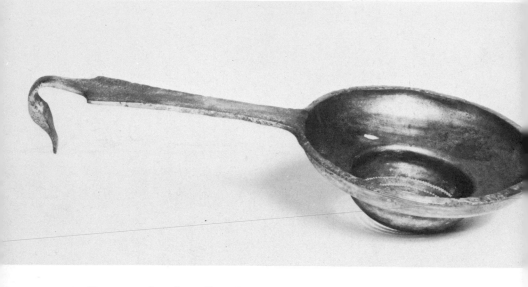

a. Bronze strainer from Grave IV.

b-c. Chalcedony scaraboid from Grave V.

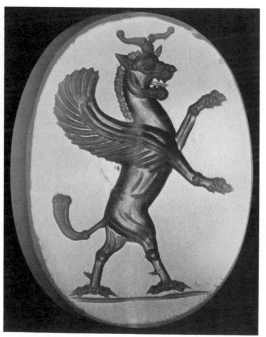 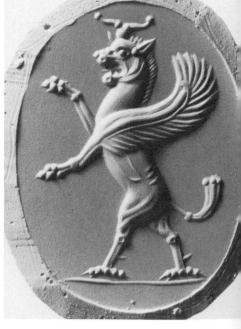

Plate XV

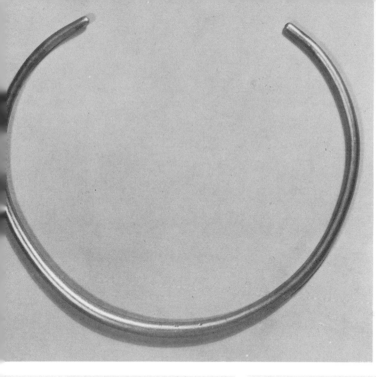

a. Electrum torc
from Grave VI.

b-c. Scale armour
from Grave VI.

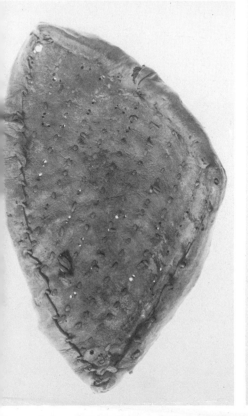

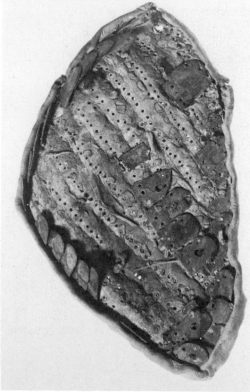

Plate XVI

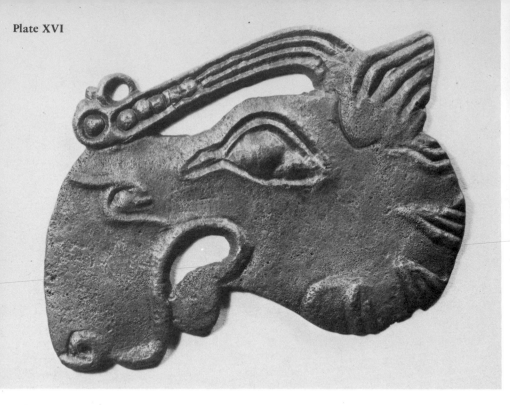

a. Bronze elk's head plaque from Grave VI.

b. Greave from Grave VI.

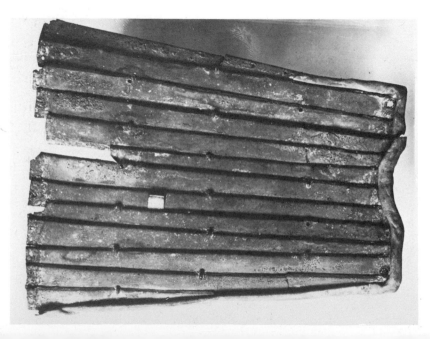

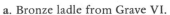

Plate XVII

a. Bronze ladle from Grave VI.

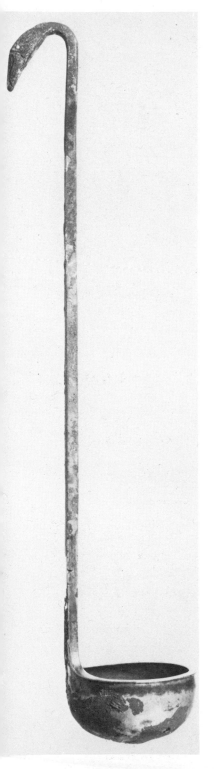

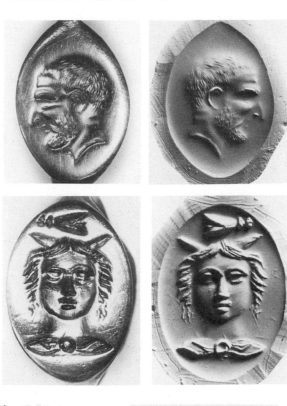

b-e Gold rings.

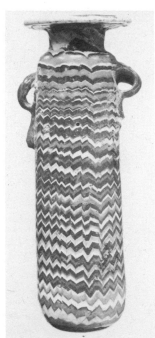

f. Glass alabastron.

Plate XVIII

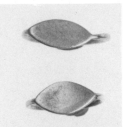

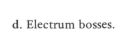

a-b Electrum rings.

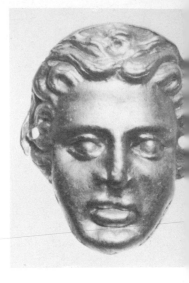

d. Electrum bosses.

c. Female head
 gold appliqué.

e. Gilt bronze bracelets.

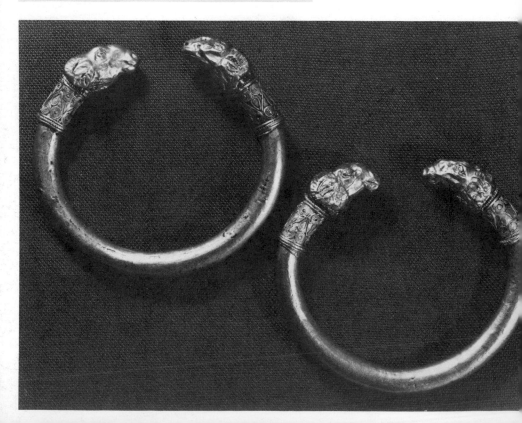

Scythian Treasures

Catalogue

Plate Ia-c Helmet probably from Grave I(a)

The helmet now consists of two pieces, the crown itself and a small peak rivetted on to the front. Along the top of the helmet from front to back are two raised parallel ridges with three parallel lines incised between them. This feature would have served as the setting for the crest. The holes around the lower edge of the helmet would have been for the attachment of a lining as well, perhaps for further protection of metal or leather or both for the neck. The small triangular nicks on the sides recall those on Illyrian helmets, a type which is found especially in Northern Greece and the Balkans. It has been assumed in the past that this helmet was a 'late variant' of the Illyrian helmet (e.g. Chernenko 1966), but Mr Brian Shefton has made the extremely plausible observation that what we have here is in fact a normal Illyrian helmet which has been trimmed down and fitted with a peak. The cranium in Plate IIc, which was definitely found in Grave I(a), fits in the helmet which is, surprisingly, not mentioned in any of the original excavation accounts, although Gross made a drawing of it. The fact that the owner of the cranium had suffered a severe blow to the head (from which he had recovered) may account for his acquiring this helmet which is both thick and soft (Vickers Hardness 86.7). All good quality helmets were annealed so as to soften the metal. The reason why this was done was so that the force of a blow would be spread over the surface. Indentations would merely cause bruises, whereas armour made from hard metal was more likely to split open with more harmful results. Lyutsenko's Report stated that the helmet was of gilt bronze, but an X-ray fluorescence examination has established that this was not the case.

1885.464. H: 14.5 cm; W: 17.5 cm; L: 21.5 cm. Lit.: Report, 8; Gardner, 65-6, pl. 46.2; the substantial subsequent literature can be found in Chernenko 1970, 193-4, n. 7. The fullest account of Illyrian helmets is by V. Lahtow in *Situla* viii (1965) 47-75. The question of hardness and softness of Greek armour is treated by P. H. Blythe in an unpublished Ph.D thesis *The effectiveness of Greek armour against arrows in the Persian War (490-479 B.C.): an inter-disciplinary study* (Reading, 1977).

Plate IIa-b Arrowheads from Grave I(a)

There are twenty-three arrowheads in all, twenty-two bronze and one bone. The shafts, of reeds, were extant when found, and fragments still remain in some of the sockets. The bronze examples are all triangular in form but fall into four different types which have been distinguished by Chernenko: (1) arrowheads with hollow sockets and with grooves as far as the tip; (2) socketed arrowheads with convex ribs and with grooves cut on three sides; (3) socketed arrowheads with the ends of the barbs shorn off with longer sockets and grooves to the tip; (4) socketed arrowheads with convex ribs, with barbs which extend beyond the socket and are marked with an oblique cross. All types are common in finds of arrowheads in the Northern Black Sea area.

34

1885.467. L (of longest): 4 cm; (of shortest): 2.7 cm. Lit.: Biller, I; Lyutsenko, 54; Gardner, 65, 68, pl. 46.5; Chernenko 1970, 198.

Plate IIc Cranium from Grave I(a)

The cranium of a male aged between 25 and 35. There are one or two unusual features: the crack across the forehead could not have been the fatal blow, for it appears to have healed up during the warrior's lifetime. He also seems to have suffered from a deviated saeptum. This cranium (and the mandible in Plate IId) have had a curious history since their discovery. They were exhibited with the Nymphaeum finds in the University Museum between 1880 and 1885, but as natural history specimens they were not transferred to the Ashmolean with the other material. Enquiries revealed that they had been deposited in the British Museum (Natural History) at South Kensington, and they were reunited with their grave goods only in 1973.

1973.21. Circumference: 51 cm. Lit.: Biller, I; Lyutsenko, 54; Gardner, 64.

Plate IId Mandible from Grave I(b)

The jawbone of an adult female. Confused by Biller with the male cranium in Plate IIc and thought to belong to it, but identified as female by Miss R. Powers. This evidence confirms Lyutsenko's statement that Grave I was a double burial of a warrior and a woman.

1973.22. L: 9 cm; W: 10.7 cm. Lit.: Biller, I.

Plate IIIa Pair of gold boat-shaped earrings from Grave I(b)

These boat- (or leech-) shaped earrings terminate with the heads of the griffins. The 'boats' are decorated with bands of wire (including double rows of twisted wire to give the illusion of cable patterns) and groups of granules arranged in triangles. The point where the 'tail' is attached is in the form of a rosette. Both are hollow and are made up from several pieces: the 'boats' in two parts, the join disguised by means of the gold wire on top and bottom. The griffin heads too were made in two parts, and such features as the ears, tongues and the knobs on the foreheads would have been added. They *are* griffin heads, and not cocks, as has sometimes been suggested, and are thus highly appropriate motifs for Scythian gold work, for griffins were the legendary guardians of the Central Asiatic gold-fields. Boat-shaped earrings are very common in Scythian graves: a pair sold at Sotheby's in 1871 (*Sale Catalogue* 24.6, Lot 237) now in the National Museum, Copenhagen (Inv. 472) may well come from the illicit excavations at Nymphaeum as well.

1885.468. H: 6 cm. Lit.: Biller, I; Lyutsenko, 54; Gardner, 68, pl. 46.6
 ('cocks'); K. Hadaczek, *Die Ohrschmuck der Griechen und Etrusker* (Vienna,
 1903) 22, fig. 42; Rostovtzeff, 79, pl. 16.2; Becatti, no. 293a-b, pl. 75
 ('cocks'); B. Aleksova, 'Où est enterrée Marie Paléologue?', *Archaeologia
 Iugoslavica* iii (1959) pl. 46, no. 9; Higgins, 122, pl. 24g ('cocks').

Plate IIIb Bronze mirror from Grave I(b)

Plain, except for a small volute near the handle (which is missing). This is a small version of a class of mirror that was exported in a luxury edition from Athens to Southern Russia in the fifth and fourth centuries B.C. These often had the volute decoration at the handle enhanced with the addition of gold leaf. The reflecting surface would have consisted of a plating of tin (which is less prone to tarnishing than silver).

1885.488. D: 10.6 cm. Lit.: Biller, I; Lyutsenko, 54; Gardner, 65.

Plate IVa (Fig. 2) Attic red-figure squat lekythos from Grave I(b)

The decoration on this squat lekythos shows two fawns seated on either side of a tree. The surface of the vase has flaked off so that only one deer is properly visible. Lyutsenko speaks of three clay lekythoi with painted decoration, and Biller a single pottery 'tearjug' with drawings on it, but 'wholly destroyed and decomposed'. The other pottery that we have, both painted and plain, can be accounted for, and it looks very much as though this is the sole survivor of the decorated wares from Grave I(b). The shape and decoration belong in the late fifth century B.C., which is the probable date of the burials in Grave I.

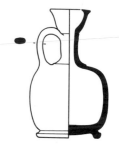

Fig. 2 3:1

Squat lekythoi have been found in other graves at Nymphaeum, and also in tombs in Athens itself.

1885.500 (V.538). H: 10 cm; D: 5.6 cm. Lit.: Biller, I; Lyutsenko, 54; Report,
 3; Gardner, 65; P. Gardner, 71; *CVA* Oxford i, pl. 40.20. Squat lekythoi at
 Nymphaeum: Silant'eva, 33, fig. 11; at Athens, e.g. *Archaiologikon Deltion*
 xxv/2 (1970) pls. 65c, 70d; their chronology; *Agora* xii, 153-4. For deer as an
 element in the Scythian diet, see the discussion of Plate IVb-c.

Plate IVb-c Eighty-four gold hare appliqués from Grave I(b)

These hares would originally have been sewn on to a garment by means of eyelets soldered on to the backs, but which are now lost. In this respect they differ from the general run of gold appliqués which usually have holes pierced in them (cf. the lions in Plate XII). There is a vast range of subject matter on these appliqués which have been found in contexts implying that they once adorned *inter alia* men's trouser legs, women's hoods or, as here, women's dresses. Some are stylised in the Scythian manner (cf. the elk's head in XVIa) while others, like our hares and lions are relatively realistic. It has been proposed that Greek coin-types may underlie some of the latter variety and the existence of several coins with hares (though none quite like ours) suggests that there may have been similar influence here. A bronze stamp and a matrix for the production of gold appliqués has recently been published. Hares are frequently represented on the

36

artefacts found in Scythian tombs (we might compare, for example, the askos in Pl. VIIIa or the gold plaques with running hares in Copenhagen [Inv. 88; acquired in 1867/8, and hence perhaps looted from Nymphaeum] and Paris [Cabinet des Médailles, Bij. 225]) and they were a standard item in the Scythian diet: a recent analysis of animal bones from a settlement site in the Eastern Crimea shows that hares were the most common form of meat after cattle, horses, sheep, pigs and deer. A hare is said to have played a crucial role in the Scythians' relations with the Persians in 519/513 B.C. Herodotus (iv, 134) tells how King Darius, at the head of a Persian host which was making a deep sortie into Scythian territory, was frustrated at not being able to bring his opponents to battle. Eventually the Scythians did draw up in battle array, but as they stood there 'it chanced that a hare started up between them and the Persians, and set to running; when immediately all the Scyths who saw it rushed off in pursuit, with great confusion and loud whoops and shouts'. At which, Darius was humiliated, gave up the attempt to conquer the Scythians and turned back. 1884.469. L: 1.1 cm. Lit.· Biller, I; Lyutsenko, 54; Gardner, 68-9, pl. 46.7.

 Appliqués on trouser legs: *Bulletin* no. 72; *Or des Scythes* no. 66; on women's hoods: T. V. Miroshina, *Sovietskaya Arheologiya* 1977/3, 79-91. Greek coin types with hares: S. L. Cesano, *Scritti in onore di Bartolomeo Nogara* (Vatican City, 1937) 89-94. Matrix: B. A. Shramko, *Sovietskaya Arheologiya* 1970/2, 217-21. Hares in the Scythian diet; B. I. Bibikova, 'Fauna from the settlements in the village of Kirov' in Leskov 1970, 97.

Plate Va-b Textile fragments from Grave I(b)

The textile fragments from Nymphaeum have been divided by Dr John Peter Wild into two sorts: *Textile 1*. A fine wool textile in plain weave, now dark brown in colour and brittle. About 9 cm^2 of it survive, but there are no selvedges. System 1 (the warp) is widespread, at *c*. 14 threads per cm and System 2 (the weft) rather closer together, at *c*. 60-70 threads per cm. *Textile 2*. A mass of loose strands of yarn, mostly dark brown and purple-brown, though some are apparently black and dark green, which may be due to discoloration rather than dye. The strands are identical with System 1 of Textile 1 but there is no trace of another system. If one did exist, it may have been of very fine yarn of vegetable origin. There are also some pieces of cord. The fibre has been analysed by Dr M. L. Ryder and has proved to be of wool, spun from the fleece of a fine-wool sheep, and is much the earliest example of this fleece-type. It has been suggested by Dr Wild that the textiles were imports from Miletus, Milesian fine-wool sheep being famous in antiquity, and trading links between Miletus and the Black Sea being particularly close. Nymphaeum, indeed, was a Milesian colony. 1885.475-478. Lit: Biller, I; Lyutsenko, 54; M. L. Ryder, J. W. Hedges, 'Ancient Scythian wool from the Crimea', *Nature* ccxlii (1973) 480; J. P. Wild, 'Classical Greek textiles from Nymphaeum', *Journal of the Textile Museum* iv/4 (1978) 33-4.

Plate VI-a Necklace of gold rams' heads from Grave II

There are twenty-six more or less identical pieces. Each was made in two halves, the sheet metal being impressed into a mould. The joins are quite visible in most cases. The eyes were added later as was a triangular patch of granulation on the forehead.

1885.493. L (of each head): 1.5 cm. Lit.: Biller, II; Gardner, 65, 72, pl. 47.12.
 For joining and granulation techniques see Hoffmann and Davidson, 24-48.

Plate VIb-c (Fig. 3) Gold ring with sphinx from Grave II

Fig. 3 2:1

The bezel has an intaglio of a crouching winged sphinx on a hatched exergue; in the corners, sprigs of olive. The style of the decoration on the bezel, and the form of the ring (stirrup-shaped with a flat, slim, leaf-shaped bezel) have led Boardman to date this ring to the second quarter of the fifth century, and to attribute it to his Penelope Group. Of the five gems in this group three have South Russian provenances, and one, of a flying Nike with a wreath, also comes from Nymphaeum.

1885.492. L (of bezel): 1.7 cm. Lit.: Biller, II; Report, 1; Gardner, 65, 72,
 pl. 47.11; Boardman *GGFR*, 215, 296, pl. 657; *Finger Rings*, 34, no. 59;
 Boardman *CEGFR*, 30, pl. 23, no. 129.

Plate VId Gold dress fasteners from Grave II

These unusual objects were found at the shoulders of the deceased, and are assumed, probably correctly, to have served as dress fasteners. Each ring was made in two halves, which were decorated and joined together along their sides. The actual fasteners are at the ends which interlock with pairs of eyelets on the tips of the penannular rings. The rings are very flimsy and cannot have held much weight. They may have served rather as buttons, for Greek buttons could be ring-shaped.

1885.494. D: 4.2—4.8 cm. Lit.: Biller, II, Gardner, 65, 72, pl. 47.13. On Greek
 buttons, see K. Elderkin, 'Buttons and their uses on Greek garments',
 American Journal of Archaeology xxxii (1928) 333-45.

Plate VIIa-b (Fig. 4) Attic red-figure askos from Grave II

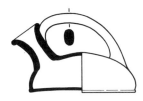

Fig. 4 3:1

Biller's account states that the preserved pieces of pottery from Grave II were labelled Plattengrab No. 2, and all the pottery in Plates VII-IX bear small nineteenth-century labels on their undersides to this effect. This askos bears on one side a satyr pouring wine into a drinking horn from an amphora and on the other another satyr crawling towards him extending his drinking horn. Beazley dated this askos to *c.* 430 B.C. Satyrs were regarded as behaving in ways which transgressed normal rules of conduct. Thus the crawling and crouching poses adopted by

38

these two are ungentlemanly in Greek terms: squatting was considered to be completely undignified and suitable only for slaves. And no self-respecting Greek would drink his wine neat or without its being strained. The presence of drinking horns is interesting, for they were a characteristic Scythian vessel and actual examples are known as well as frequent representations in Greco-Scythian art. The preponderance of motifs with apparent Scythian significance amongst the decorated pots in our grave groups (in addition to these drinking horns, the deer on the lekythos in Plate IVa, and the hound and hare on the askos in Plate VIIIa) suggests that some care went into the design of Attic pottery for the Scythian market or that Scythian clients in Athens were fairly explicit in their orders.

1885.499 (V.541). H: 6.5 cm; D: 8.8 cm. Lit.: Report, 4; Gardner, 65;
 P. Gardner, 72; *CVA* Oxford i, pl. 45.2; Hoffmann, 6, 12, no. La2. Squatting
 a shameful posture: N. Himmelmann, *Archäologisches zum Problem der*
 griechischen Sklaverei (Mainz, 1971) 36. Satyrs as transgressors: Hoffmann,
 4-6. A satyr drinking wine directly from the press: B. A. Sparkes, 'Treading
 the grapes', *Bulletin Antieke Beschaving* li (1976), pl. 57.4. Drinking horns
 in Scythian art: *Bulletin*, nos. 72, 74, 76, 79; *Or des Scythes*, nos. 66a, 96-97,
 105.

Plate VIIIa (Fig. 5) Attic red-figure askos from Grave II

The motif of a hound chasing a hare is a common one in Scythian art, and was too, presumably, in Scythian life. There are hounds chasing hares on the pectoral from Tolstaya mogila (p. 12, above) and elsewhere, and it seems likely that this askos was designed specifically for the Scythian market. Beazley dated it to the late fifth century.

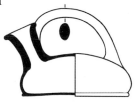

Fig. 5 3:1

1885.498 (V.542). H: 6.9 cm; D: 8.8 cm. Lit.: Report, 4;
 Gardner, 65; P. Gardner, 73; *CVA* Oxford i, pl. 45.4; J. D. Beazley, *Attic*
 Red-figure Vase painters, 2nd edition (Oxford, 1963) 964.9 (near the
 Painter of London D12); Hoffmann, 11, no. Aa7 (add an askos from tumulus
 VI of the Seven Brothers Barrows in Kuban with a lion chasing a hare, *Compte*
 Rendu de la Commission Archéologique Impériale 1876, 130-31).

Plate VIIIb (Fig. 6) Attic black-glaze cup-skyphos from Grave II

The pot is delicately made. The bowl has a single curve, the upper side of the foot is convex, and the foot is black underneath. Probably to be dated to the end of the fifth century B.C.

Fig. 6 3:1

1885.497. H: 5.6 cm; D: 10.8 cm. Lit.: Biller, II; Gardner, 65, *CVA* Oxford i,
 pl. 48.3. Dr Sparkes compares *Agora* xii, 273, no. 539 (of *c*. 420 B.C.).

Plate IXa-b (Fig. 7) Attic black-glaze stemless cup from Grave II

Fig. 7 3:1

A stoutly made drinking vessel with an offset lip. The side of the foot is lipped and reserved. The underside is reserved and has a black dot and circle in the middle. There is a graffito Achaxe, probably an owner's name, beneath. Several similar cups of equally massive proportions (including one bearing the Greek graffito 'a cup of good cheer for us': Silant'eva 43, fig. 20) have been found at Nymphaeum. Mr Brian Shefton will show, in the forthcoming publication of his Edinburgh Monroe Lectures that such cups, which he calls Castulo cups and which are rather more stoutly made than most Attic products, have a remarkably interesting distribution pattern. They occur in Scythian territory (one has been found as far east as Aksyutintsy, 170 km east of Kiev), in Campania and Sicily, and in Spain and Ibiza, but surprisingly do not occur in Etruria. They used to be dated to the first half of the fifth century B.C., but it now seems that they were made well into the second half. This makes sense in the present context, for all the other pottery from Grave II was certainly made in the second half of the fifth century.

1885.495. H: 7.5 cm; D: 21.2 cm. Lit.: Biller, II; Gardner, 65; *CVA* Oxford i, pl. 48.2; *Agora* xii, 268, no. 470. Aksyutintsy cup: N. A. Onaiko, *Classical Imports . . . in the 7th-5th Centuries B.C.* (in Russian), Collection of Archaeological Sources (Svod Arheologicheskih Istochnikov) D1-27 (Moscow, 1966) 61-2, no. 168, pl. 9.9. Achaxe is not referred to by L. Zgusta, *Die Personennamen griechische Städte der nördlichen Schwarzmeerküste* (Prague, 1955).

Plate IXc (Fig. 8) Attic black-glaze lekanis from Grave II

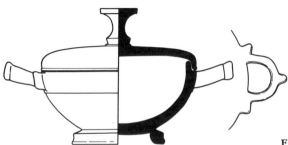

Fig. 8 3:1

Elegantly turned lekanides (cosmetic boxes) of this type are called Lykinic after the graffito found on the lid of one example. This lekanis has a deep bowl, wishbone handles and an unusual knob which is reserved on top and decorated with concentric circles. Parallels found in the Athenian Agora have been dated to 430-420 B.C., which is probably when this was made.

1885.496. H: 10.8 cm; D: 12.2 cm. Lit.: Biller, II, Gardner, 65; *CVA* Oxford i, pl. 48.19; *Agora* xii, 168-70.

Plate Xa Electrum necklace from Grave III

This necklace consists of twenty-five units, each consisting of a rectangle of sheet metal from which a fluted or knobbed bead is suspended. Eight of the rectangular plates are larger than the others and bear rosettes of gold wire (some have two beads suspended from them). As reconstructed, these plates alternate with the regular ones at the centre of the necklace. Part of the fastener is preserved: a trapezoidal piece of metal folded over on the long edges to provide the mooring for a pair of threads the correct distance apart to carry the rectangular plates.

1885.502. L: 25 cm. Lit.: Biller, III; Gardner, 66, 71-2, pl. 47.9; Becatti, no. 425, pl. 115; Higgins, 127, pl. 27a.

Plate Xb Silver and electrum bracelets from Grave III

The finials of these silver bracelets are in the form of lions' heads, done in electrum. Their worn and fragile condition enables us to see clearly how they were constructed: the heads each made from two pieces of sheet metal, and the necks from a strip of electrum mounted with pieces of twisted wire laid side by side. Normally this is meant to create the illusion of a cable pattern, but in two cases here the wires have been laid rather carelessly and can be seen for what they are. The lions' heads closely resemble those on the finials of a gold torc found in a Scythian tomb at Kakhovka in 1969. The penannular form of these bracelets recalls that of Achaemenid bracelets, and they may well have been made under Persian influence.

1885.503. D: 7.4 cm. Lit.: Biller, III; Report, 5; Gardner, 66, 72, pl. 47.10.
Kakhovka torc: Leskov 1974, 73, fig. 103.

Plate XIa-b Gold necklace from Grave IV

There are few more exquisite pieces of jewellery from the classical period than this necklace. Twenty-two rosettes with acorns suspended from them alternate with stylised lotuses which support small beads. Both rosettes and lotuses each have another, much smaller, rosette attached to them. All these elements are made of sheet gold edged with beaded gold wire. They may well have once been enamelled, for Gross refers (Appendix III) to 'rosettes from which the enamel has been reduced to powder' and he must have seen traces that were removed by subsequent cleaning (in a letter from Siemens of November 1880 on file in the

Ashmolean, reference is made to the fact that 'the gold [of the acorn necklace] was rubbed to show the effect, whereas all the other ornaments have been left just in the condition in which they were found'. The acorns are very realistically made: the striated cups joined to the smooth glands, the junction cleverly disguised. We are reminded of Aristophanes' lines in the *Lysistrata* (408-413) with their none-too-subtle *doubles entendres*: 'Goldsmith, you know the necklace that you repaired: as my wife was dancing the other evening, the acorn fell out of its hole. I have to sail to Salamis; if you have the spare time, could you do your best to come this evening and put the acorn back?' Three necklaces found in a burial of the first half of the fifth century B.C. at Eretria in Euboea recall features of two of our pieces and perhaps indicate the general area from which they (or the craftsmen who made them) came. They all have acorns and one has a bull's head decorated with triangular blocks of granulation rather like those on our rams' head necklace (Plate VIa).

1885.482. L: 31 cm. Lit.: Biller, IV; Report, 1; Gardner, 66, 70, pl. 47.4; Rostovtzeff, pl. 16.4; Becatti, no. 426, pl. 115; P. Coche de la Ferté, *Les bijoux antiques* (Paris, 1956), pl. 20.2; Higgins, 127, pl. 276B. Eretria necklaces: K. Kuruniotis, *Athenische Mitteilungen* xxxviii (1913) 316-19, pl. 15.

Plate XIc Hair ornaments from Grave IV

These objects are made of bronze with an electrum casing and terminals. These last consist of pyramids and granules and collar ornaments of wire figure-of-eight spirals with granules in the loops. Biller took them to be clothes fasteners, and such objects are often called 'earrings', but it is difficult to see how they could have been used as such.

1885.483. H: 3.5 cm. Lit.: Biller, IV; Gardner, 66, 70-71, pl. 47.5; Rostovtzeff, pl. 16.3; Becatti, no. 378, pl. 99; Higgins, 123, pl. 24f.

Plate XIIa-b Forty-nine gold lion appliqués from Grave IV

These lions, like the hares above (Plate IV b-c), would have been sewn on to a garment, but unlike them have holes pierced in them for this purpose. In this respect they resemble the majority of appliqués from Scythian graves. Although they are done in a summary fashion these lions are in no way stylised. Rather, they appear realistically alert and ready to pounce on their prey.

1885.480. L (of each): 1.3 cm. Lit.: Biller, IV; Gardner, 70, pl. 47.3.

Plate XIIIa (Fig. 9) Silver cup from Grave IV

This cup is one of the very few pieces of of plate that have survived from the fifth century B.C. Most have gone into the melting pot. The bowl of this cup was hammered out from a disc of silver; the lip was tooled inside and out and the underside decorated with three

Fig. 9 3:1

42

concentric tooled ridges on a lathe. The handles and foot were cast separately and soldered on. The only close parallel in silver comes from Vouni in Cyprus, but similar shapes exist in Attic black-glaze pottery of the late fifth century, and there is an unpublished bronze example in the National Museum in Copenhagen. A silver cup of the third quarter of the fourth century was found at Taman on the Kuban peninsula.

1885.486. H: 5.6 cm; D: 10.5 cm; W: 16.2 cm; Wt.: 289 gm. Lit.: Biller IV; Gardner, 66; D. E. Strong, *Greek and Roman Gold and Silver Plate* (London, 1966) 85, pl. 17a; *Agora* xii, 111, n. 21; *Silver for the Gods,* 31, no. 6. Vouni cup: E. Gjerstad *et al., The Swedish Cyprus Expedition* iii (Stockholm, 1937) 238, 274, no. 292d, pls. 90, 92. Taman cup: B. Pharmakowsky, 'Archäologische Funde im Jahre 1912: Russland', *Archäologischer Anzeiger* 1913, 181-5, fig. 13.

Plate XIIIb-c Bronze patera handle from Grave IV

The bowl of the patera (libation dish) is missing, a fact which has led to this handle frequently being connected with the mirror disc in Plate XIIId. It is clear, however, from the way that the junction point curves (as though to meet the rounded bowl of a patera) that it was never intended to be joined to a flat mirror. Patera handles of this type, with a thumb rest on the upper surface, volute and palmette decorations, and an ornate suspension hole, are generally thought to be Etruscan in origin. The suggestion has accordingly been made that this is an Etruscan import, an idea which gains support from the recent discovery of a similar handle on a wine strainer at Melfi in Southern Italy.

1885.470a. L: 18 cm. Lit.: Biller, IV; Gardner, 69, pl. 46.9; P. Jacobsthal and A. Langsdorf, *Die Bronzeschnabelkannen: ein Beitrag zur Geschichte des vorrömischen Imports nördlich der Alpen* (Berlin/Wilmersdorf, 1929) 46-7, n. 6. e. Kunze, 'Etruskische Bronzen in Griechenland', *Studies presented to D. M. Robinson* i (St Louis, 1951) 743, n. 29; Z. A. Bilimovich, 'Etruscan bronze wine strainers found on the Northern Black Sea coast', *On the History of the Northern Black Sea Coast in Antiquity* (in Russian) (Leningrad, 1978) 33, n. 43 Melfi strainer: W. Hermann, *Archäologischer Anzeiger* 1966, 317, figs. 82-83.

Plate XIIId Bronze mirror disc from Grave IV

This mirror disc has frequently been associated with the patera handle in Plate XIIIb-c, but this is unlikely. Instead, the handle was probably made of another material — wood, bone, ivory or iron — which has disintegrated or corroded away.

1885.470b. D: 17.5 cm. Lit.: Biller, IV; Gardner, 69.

Plate XIVa Bronze strainer from Grave IV

Strainers of this kind, with a sieve depressed in the centre of the bowl and a duck's head handle, were very common in the Greek world, and many have

survived. They were, after all, part of any respectable drinking man's equipment. Wine straight from the amphora would have contained impurities that the average bibber would prefer not to drink. A strainer of this kind can be seen suspended (together with a ladle) on a cup by Makron in New York.

1885.487. L: 24.6 cm; D: 11.8 cm. Lit.: Biller, IV; Report, 7; Gardner, 66. New York cup: Mertens, 74-5, fig. 7.

Plate XIVb-c Chalcedony scaraboid from Grave V

This ferocious-looking winged horned lion belongs to the Achaemenid menagerie of mythological beasts, and serves as a reminder of the close links the Scythians had with Persia. It belongs to a class of gems known as 'Greco-Persian' which were made in the later fifth and fourth centuries B.C. by Greek craftsmen for Persian clients. Many have been found in Scythian graves, but few are as grand as this example.

1885.491. H: 2.7cm. W: 2 cm. Lit.: Biller, V; Report, 9; Gardner, 66, 71, pl. 47.8; A. Furtwängler, *Antike Gemmen* (Leipzig/Berlin, 1900), pl. 12.4; Rostovtzeff, pl. 16.1; G. Lippold, *Gemmen und Kameen* (Stuttgart, 1922), pl. 81.2; Boardman *GGFR*, pl. 838. For numerous Graeco-Persian gems from Scythian contexts: Minns, 411, fig. 298.

Plate XVa Electrum torc from Grave VI

Neck decorations such as this are fairly common in Scythian burials. They can be as simple as this (compare the one in Tumulus 24 found in 1876, p. 11, above), or have decorated terminals. One with lions'-head terminals similar to those on our silver bracelets (Plate Xb) was found recently at Kakhovka, and the most elaborate of all, from Kul Oba near Kerch, has a pair of Scythian riders astride each end.

1885.472. D: 17.5 cm; Wt.: 165 gm; Lit.: Lyutsenko, 55; Gardner, 65. Kakhovka torc: Leskov 1974, 73, fig. 103; Kul Oba torc: *Bulletin*, no. 83; *Or des Scythes*, no. 92.

Plate XVb-c Fragment of scale armour from Grave VI

This is merely a part of the leather cuirass that Lyutsenko reported from Grave VI. It once had eleven rows of bronze plates sewn on to a double leather backing by means of thongs of rawhide. and the whole piece is sewn around with a leather strip. It seems likely from the shape of this piece of armour, and from the discovery of a similar fragment in a tumulus at Volkovtsy, that it was one of the epaulettes of the leather cuirass. Dr R. Reed has identified the main part of this object as being made of sheep- or goat-skin, while the edging is probably of calf-skin. In contrast with the soft metal of the helmet (Plate I), the bronze plates are still work-hardened (Vickers Hardness 175).

1885.465. L: 22.5 cm: W: 13 cm. Lit.: Lyutsenko, 55; Gardner, 67, pl. 46.3; Chernenko 1970, 193-4, fig. 2. Volkovtsy tumulus: E. V. Chernenko, *Arheologiya* xvii (Kiev, 1965) 150, figs. 6-7.

Plate XVIa Bronze elk's head plaque from Grave VI

This impressive elk's head is the only major piece of Scythian artistry amongst the finds from Nymphaeum in Oxford. It has a pendulous lower lip and a huge over-hanging nose, summary nostrils and a large staring eye surrounded by deeply incised lids. The ears and mane are also incised. The horn is as small as the nose is large, in keeping with the highly stylised nature of the object; indeed, it terminates in the form of a stylised bird's head. On the back is a small bracket with which it was attached to the breastplate. It seems likely, at least, that this was the case, although as Chernenko notes, the ten or so similar elks' head plaques found in other Scythian graves were not actually recorded *in situ*. Two more elks' head plaques have been found at Nymphaeum, as well as lions' head plaques made in a very similar manner. This style, the 'animal style', was extremely widespread in Asia, and related artefacts have been found as far as Mongolia, and even beyond.

1885.466. H: 8.3 cm; W: 11.6 cm. Lit.: Lyutsenko, 55; Report, 2; Gardner, 67-8, pl. 46.4 ('camel'); M. Rostovtzeff, *The Animal Style in South Russia and China* (Princeton, 1929), pl. 10.7; Talbot Rice, pl. 44; Chernenko 1970, 194-5, fig. 3. Elks' and lions' head plaques from Nymphaeum: Silant'eva, 84-5, figs. 47-48.

Plate XVIb Bronze and leather greave from Grave VI

This greave is but one of the pair mentioned by Lyutsenko in his description of Grave VI. It consists of thirteen bronze strips attached by means of bronze wire to a backing of sheep- or goat-skin, the whole edged in calf-skin (identifications by Dr R. Reed). There are no traces of any arrangements for attaching the greave to the ankle, and it was probably pushed into a boot or a sock like a footballer's shin-pad. The indentation at the bottom was clearly intended to fit over the foot.

1885.463. L: 20.4 cm. Lit.: Lyutsenko, 55; Gardner, 66, pl. 46.1; Chernenko 1970, 195-7, fig. 4.

Plate XVIIa Bronze ladle from Grave VI

This ladle consists of a fairly shallow bowl, a stem square in section and a goose-head terminal. And it is without doubt a goose's head, rather than the duck's head that is more customary in such contexts (cf. the duck's head on the strainer from Grave IV [Plate XIVa]). It has the characteristic beak of a goose and the eyes and neck-feathers are clearly shown. Ladles were part of the standard equipment for a symposium: the wine would be poured from an amphora (like the one the satyr is wielding in Plate VII) into a crater where it would be mixed with water. Then it would be dispensed into drinking cups (like those in Plates VIIIb, IXa, or XIIIa) by means of a jug or a ladle. The form of our ladle is what we might expect towards the end of the fifth century B.C. Earlier in the century, the bowl was deep and egg-shaped, and by the late fourth century it had become

lower and wider, shallower even than ours. The handles are flat by this time and often have decorative volutes at the point where the bowl and handle meet. This is almost certainly the ladle mentioned by Lyutsenko, despite the fact that the handle of his was said to be broken.

1885.473. L: 34.5 cm. Lit.: Lyutsenko, 55; Report, 6; Gardner, 65. For ladles, their use and development: Mertens, 71-8, and M. Vickers, *Burlington Magazine* cxxi (1979), forthcoming.

Plate XVIIb-c (Fig. 10) Gold ring with bearded man

The surface of the bezel is much worn, but it is still possible to make out the features of a middle-aged man with high cheek bones, an aquiline nose, short hair and a stubbly beard; features which strongly suggest that we have here a portrait of a specific individual. This is a rare,

Fig. 10 2:1

but not unparalled phenomenon in the second half of the fifth century B.C., and we might compare, for example, the striking jasper scaraboid in Boston with the portrait of another bearded man and signed by the gem cutter Dexamenos (Boardman *GGFR*, pl. 466). The form of our ring, with its slightly curved swollen bezel, has been dated to the third quarter of the 5th century B.C. by Boardman who includes it in his Classical Light Ring group.

1885.484. L (of bezel): 1.4 cm. Lit.: Report, 1; Gardner, 66, 71, pl. 47.6; J. D. Beazley, *Lewes House Gems* (Oxford, 1920) 48, pl. A.29; P. Jacobsthal, *Die melischen Reliefs* (Berlin, 1931) 156, fig. 35; G. M. A. Richter, 'The Greek portraits of the fifth century B.C.', *Rendiconti della Pontificia Accademia Romana di Archeologia* xxxiv (1961-62) 56-7, fig. 25; Richter, no. 325; Boardman *GGFR*, 296, pl. 670; D. Metzler, *Porträt und Gesellschaft* (Münster, 1971) 311, fig. 26; *Finger Rings*, 34, no. 60; Boardman *CEGFR* 30, pl. 23, no. 131.

Plate XVIId-e (Fig. 11) Gold ring with a facing head

The precise interpretation of this intaglio is uncertain. Is it a youth wearing a chlamys with *wings* on his head, as Richter suggested, or are they *horns* like those worn by river gods, as Boardman proposes? The cicada above his head is puzzling, too, but Boardman tentatively connects

Fig. 11 2:1

it with the Greek word for both a cicada and a male hair ornament (*tettix*). The form of the ring with its oval bezel is one prevalent in the fourth century B.C., and Boardman places it in his Nike Group (eleven rings, five of which are from Southern Russia).

1885.490. L (of bezel): 1.6 cm. Lit.: Gardner, 66, 71, pl. 47.7; Richter, no. 317; Boardman *GGFR*, 223, 299, pl. 730; *Finger Rings*, 35, no. 71; Boardman *CEGFR*, 31, pl. 25, no. 135.

Plate XVIIf Glass alabastron

This alabastron is a fifth-century version of a well-known type of vessel made on a core, perhaps of clay (but not of sand). Molten glass was wound around the core and smoothed ('marvered') on a flat stone slab before being combed into festoons or zig-zags, as here. The colours of this piece — light blue, brown and yellow — are slightly unusual. The place of manufacture is unknown, and it is unlikely that all such core-made vessels were made only in Syria, as is often supposed, and it has been suggested that workshops may have been set up in the Aegean or perhaps in Cyprus. Other glass alabastra have been found at Nymphaeum.

1885.501. H: 10.6 cm. Lit.: Gardner, 65; P. Fossing, *Glass Vessels before Glass-blowing* (Copenhagen, 1940) 68, fig. 42. On core-made glass in general: D. B. Harden, 'Ancient glass, i: pre-Roman', *Archaeological Journal* cxxv (1968) 50, 53-5, fig. 3. Alabastra at Nymphaeum: Silant'eva, 24, fig. 8.

Plate XVIIIa, *top* (Fig. 12) Electrum ring

This ring could have come from either Grave I(b) or Grave V. It is of a form which is usual down to the middle of the fifth century B.C. (= Boardman *GGFR*, 212-13, Type I).

Fig. 12 2:1

1885.474. W: 2.4 cm. Lit.: Biller, I/V; Lyutsenko, 54; Gardner, 65-6.

Plate XVIIIb, *bottom* (Fig. 13) Electrum ring

Again the grave from which this ring came is uncertain: either Grave I(b) or Grave V. It differs from the foregoing in having a hoop shaped more to the finger and a bezel bent out in sympathy with the line of the hoop (= Boardman *GGFR*, 212-14, Type II).

Fig. 13 2:1

1885.485. W: 2.2 cm. Lit.: Biller I/V; Lyutscnko, 54; Gardner, 65-6.

Plate XVIIIc Female head gold appliqué

The long curly hair on this head argues for it being that of a woman rather than a youth. The idealising features place it in the Greek, rather than the Scythian artistic tradition. It has two holes pierced in it for sewing to a garment, but there is no evidence as to which grave it was found in.

1885.481. H: 2 cm; W: 1.2 cm. Lit.: Gardner, 69-70, pl. 47.2.

Plate XVIIId Two electrum bosses

It is uncertain as to which grave these bosses belonged; equally uncertain is their precise function. They seem to have been attached by means of brackets

(now lost) to another surface, probably a garment. There seem to be no precise parallels in other Scythian graves.

1885.471. D: 2.5 cm. Lit.: Gardner, pl. 48.8.

Plate XVIIIe Pair of bracelets with rams' head terminals

The bracelets themselves are of bronze, but are encased in gold. The terminals are in the form of rams' heads, each made as usual in two pieces joined down the centre. There are collars decorated with spirals of gold wire which somehow recall the anthemion bands that are to be found in Ionic architectural decoration (e.g. on the columns and upper cella walls of the Erechtheum at Athens). Like the lion's head bracelets (Plate Xb) their form is akin to that of Achaemenid bracelets. It is unfortunate that we do not know to which grave group these bracelets belong, but if we had to make a guess, it is most likely that they came from Grave IV which contained the rich necklace (Plate XIa) and the hair ornaments (Plate XIc) with their similar collar ornament.

1885.479. D: 8.5 cm. Lit.: Report, 5; Gardner, 66, 69, pl. 47.1; Becatti, no. 370, pl. 95.

Appendix I

Translation (from German) of Franz Biller's manuscript account of the excavation of the Nymphaeum graves, preserved in the Department of Antiquities, Ashmolean Museum, Oxford.

Grave I

A solitary tumulus (Gurgan) in which the cist grave was dug about two feet below surrounding ground level. The grave lies, like all Greek graves, from East to West. Head of the body in the East. Made from 12-inch wide slabs of white limestone worked with the mallet, such as are to be found in the neighbourhood today. In the grave stood a wooden coffin of undecorated 2-inch planks of walnut, nailed with wooden dowels. Running around the upper edge of the coffin, a moulding of walnut. The wood tolerably well preserved, only the North side, the sides and the head-end collapsing completely to the touch. In the grave was found the skeleton reduced to dust, only the cranium and lower jawbone somewhat preserved. The body was wrapped in many animal skins laid in quantity one on top of the other of which samples are enclosed. Apart from these there seem to have been woollen and silk articles present of which likewise a few remains are enclosed. Near the left hand, moreover, lay a piece of sponge and remains of two marble tearflasks, which were wholly decayed, and also a pottery tearjug with drawings on it, but wholly destroyed and decomposed. On the right hand lay a copper-gilt mirror with the handle missing and a simple gold finger ring without design. Further on the right, a bit higher up towards the head, the remains of two iron swords, one with a wooden, the other with an iron hilt. The first one shorter. Near the swords lay some copper arrows with shafts of reeds. In the region of the chest lay eight pieces of gold decorative objects which strung together formed a neck or breast ornament. At the skull lay to right and left two ear pendants. From the neck over the breast and body lay the small gold appliqués in the form of hares, which presumably served as dress ornaments or trimmings. Outside the east side of the grave lay the skeletons of a dog and a horse on the capstones of the grave. By the head of the horse, the teeth of which were pretty well preserved, lay two parts of an iron bit, completely converted into iron oxide and fragmented. .

Grave II

A small tumulus 18 feet high, standing in a row of several other tumuli containing a small woman's grave. The wooden coffin therein had on the southern long side two decorative motifs. The wood had however become so fragile that it had fallen in. Head in East, thus a Greek grave, situated in the

eastern part of the tumulus and apparently at the surrounding ground level. On the coffin, which was broken and collapsed had stood some pottery of which the preserved fragments are enclosed labelled Plattgrab No. 2. Within the coffin were found on the chest near the neck gold rams' heads which strung together had formed a necklace. There were, moreover, two large rings at the shoulders serving as fasteners to hold together the clothes, and on the right hand a finger ring with a sphinx engraved on it.

Grave III

In a small tumulus was found a small grave lying East to West, a woman's grave. The coffin as in the others was of walnut, but wholly collapsed. There were found in it two silver bracelets with terminals of sheet gold in the form of lion or panther heads, and a small necklace.

Grave IV

In a small tumulus a large 7-foot long grave. The grave lay in the Southwest quarter of the tumulus; 2 feet to 3 feet below the surrounding ground level. The wooden coffin collapsed and crushed beneath a broken lid-stone which had fallen into the grave. Coffin of walnut without any special decoration. There were found at the shoulder two fasteners for holding together the clothes, a necklace on the breast, an engraved finger ring, ornaments of embossed sheet gold in the form of small lions scattered from the neck over the breast and body, and a small silver vase near the left hand. Close by a washing sponge. On the right a gilt-copper mirror with handle, and a copper thymiaterium pierced like a sieve at the bottom. At the feet, outside the coffin, were various little wooden cups and two spindles besides the remains of a chair, all of which woodwork was quite rotten, spongy and falling to pieces when touched.

Grave V

Woman's grave on the sea-shore in a fairly large tumulus. Wooden coffin decayed, also the skeleton. In the coffin were found only a finger ring and the carved chalcedony. The chalcedony lay in the region of the neck and breast and probably served as an amulet.

Appendix II

Translation (from Russian by Professor E. Koutaissoff) of the earliest published account of the discovery of the tombs at Nymphaeum, by A.L. (A. Lyutsenko, Director of the Museum of Antiquities at Kerch) in the *Drevnosti Trudi Moskovskago Arheologicheskii Obschchestva* (Transactions of the Moscow Archaeological Society) ii (1870) 54-5.

Excavations of tumuli in the locality assumed to be ancient Nymphaea

At the end of last year two private persons, having come to an agreement with the owner of the village of Eltigen in the district of Theodosia, began a study of the tumuli there, a location assumed to be ancient Nymphaea. These excavations were triggered off by the discovery of golden earrings described in the *Arheologicheskii vestnik* (Archaeological Messenger) for 1867, p. 93. In spite of a fairly severe frost which hampered excavations for a week, the seekers of antiquities succeeded in discovering in these tumuli with the help of a drill at the depth of about two sazhens [*c.* 4.25 m] from the surface two graves which, although not rich, are nevertheless worthy of note from the point of view of archaeology. According to the above mentioned persons, in the first half of the two tombs — of a common stone construction — there was a simple wooden coffin containing two practically disintegrated skeletons, next to one of which were found: a considerable number of well preserved bronze arrow heads; one similar arrow head made of bone together with fragments of an iron sword; alongside the other — a pair of gold snail-like earrings decorated with tiny balls and terminating in griffin heads; eight smooth, square, hollow little boxes of sheet gold with ornaments having the shape of beech acorns attached to them; one small smooth ring made of electrum; more than sixty small blackened pellets of leaf gold with coarse impressions of a hare and tiny holes around the edges; fragments of a round metal mirror; a skein of extremely well preserved thread; remnants of some kind of tissue, a few nuts and three clay lekythoi with drawings badly damaged by the dampness of the soil, as explained by those who found them.

In the other grave dug out in the earth there was one wooden coffin flattened by the weight of the soil; in it was a skeleton lying with its head to the east. On its neck was a necklace made of a smooth piece of electrum weighing 38½ zoltniks; on the chest of a breast-plate (in fragments) of bronze scales fixed to an iron coat-of-mail and one well preserved plaque 12.8 cm. in length and width, with a loop on the reverse and on the right side the representation in relief of a horse-like head; on the legs were bronze knemides or shin-guards without decorations and on both sides fragments of an iron sword; a bronze kyathos or simpulum (ladle) with its handle broken off, similar to the

one pictured on plate xxx of *Drevnosti Bosfora Kimmeriiskago* (Antiquities of the Cimmerian Bosphorus), Hermitage edition (figs. 1 and 2), and three well preserved containers, covered with a shiny black paint but without design, two of which have the shape of a patera (without lid) and the third that of a small cup on a tall stem.

This is all that was found according to the testimony of the discoverers in the above mentioned graves to the opening of which the Director of the Kerch Museum had not been invited. These objects, which have nothing new or artistic about them with perhaps the exception of the earrings because of their remarkable shape, are in the keeping of those who found them.

Appendix III

Translation (from Russian) of a manuscript report by A. Lyutsenko to his superior, the original preserved in Leningrad (Archive LOIIMK, Archaeological Commission file 1867g, No. 11,101)

To his Excellency the President of the Imperial
Archaeological Commission, General Count Stroganov

From the Director of the
Museum of Antiquities at Kerch

REPORT

Accompanying this with descriptive drawings made by the painter Gross concerning the remarkable ancient objects amongst those found this year by the the industrialist Franz Biller and his companion in the tombs opened by them in the tumuli of the village of Eltegen (ancient Nymphaeum), I have the honour to forward them to your Excellency by post in a wooden box under the letter R.

In this connection I consider it my duty to inform you that neither I nor my assistant have been invited to be present at the opening of the aforementioned tombs in the village of Eltegen and that among the number of finds made there, one counts many objects damaged by the finders consequent on a lack of precautions in respect of them and certain of the objects such as already exist in the Hermitage collection. Which is why we have considered it useless to make drawings of them. Among the objects represented there merits particular attention a large chalcedony oval in form from a ring which is magnificently preserved with a remarkable intaglio upon it. Unfortunately the owners of this find, encouraged by the well-known speculators in Kerch, Odessa and Cherson, give them an extraordinarily high importance and wish to sell them together without separating them to a single person for 3,000 roubles. Considering this price excessive for the quantity and quality of the objects found, I have decided not to acquire them, and have contented myself with the faithful drawings of the best finds. Moreover, it is said that Biller and his companion occupied by some other speculation have put off the final excavation of the tumuli in the village of Eltegen until the autumn of this year.

No. 21
3 April 1869,
Kerch

Acting Counsellor of State Lyutsenko

Description of the drawings made from the ancient objects found in the stone tombs opened by Franz Biller in 1869 in the tumuli situated on the property of Madame Gur'eva near Eltegen.

Short description

1. Solid gold ring with an intaglio representing a crouching sphinx turned towards the right.

 Gold necklace with rosettes from which the enamel has been reduced to powder. The necklace carries large beads (representing acorns) 22 items and small or intermediary beads 20 items.

 Solid gold ring with a slightly worn intaglio representing a bearded male head turned to the left.

2. Cast bronze plaque from a girdle.

 Strigil in gilt bronze.

3. Clay flask in pieces with a drawing of yellow colour on a black ground.

4. Two clay flasks with drawings of yellow colour on a black ground.

5. Bracelet in bronze plated with gold.

 Bracelet in silver with gilt lion heads in gold.

6. Ladle in gilt bronze.

7. Sieve in bronze.

8. Helmet in gilt bronze.

9. Chalcedony of a ring with a graven image of artistic workmanship and of perfect preservation.

 The gold ring with the complete intaglio on it is slightly worn.

Kerch Painter Gross
3 March 1869

Bibliography and abbreviations

G. Becatti, *Oreficerie antiche* (Rome, 1955) [Becatti].

F. Biller, Manuscript account of the excavation of graves at Nymphaeum in December 1868, preserved in the Department of Antiquities, Ashmolean Museum, Oxford [Biller (Appendix I)].

J. Boardman, *The Greeks Overseas,* 2nd edition (Harmondsworth, 1973).

J. Boardman, *Greek Gems and Finger Rings* (London, 1970) [Boardman *GGFR*].

J. Boardman and M. L. Vollenweider, *Catalogue of the Engraved Gems and Finger Rings in the Ashmolean Museum* i, *Greek and Etruscan* (Oxford, 1978) [Boardman, *CEGFR*].

E. V. Chernenko, 'On helmets from Nymphaeum', *Sovietskaya Arheologiya* 1966/4, 194-6 [Chernenko 1966].

E. V. Chernenko, 'Burials with weapons in the necropolis at Nymphaeum' (in Russian) in Leskov 1970, 190-98 [Chernenko 1970].

Corpus Vasorum Antiquorum, Oxford i (Oxford, 1927) [*CVA* Oxford i].

C. M. Danoff, 'Pontos Euxeinos: Nymphaion', Pauly-Wissowa-Kroll, *Realencyclopädie*, Suppl. ix (1962) 1127-8 [Danoff].

Exhibition catalogue, *From the Lands of the Scythians, Metropolitan Museum of Art Bulletin*, xxxii/5 (1973-74) [*Bulletin*].

Exhibition catalogue, *Or des Scythes* (Paris, 1975) [*Or des Scythes*].

Exhibition catalogue, *Silver for the Gods* (Toledo, Ohio, etc., 1977) [*Silver for the Gods*].

V. F. Gajdukevič, *Das Bosporanische Reich* (Berlin/Amsterdam, 1971) [Gajdukevič].

E. A. Gardner, 'Ornaments and armour from Kertch in the New Museum at Oxford', *Journal of Hellenic Studies* v (1884) 62-73, pls. 46-47 [Gardner].

P. Gardner, 'Vases added to the Ashmolean Museum, ii', *Journal of Hellenic Studies* xxv (1905) 65-85, pls. 1-4 [P. Gardner].

R. A. Higgins, *Greek and Roman Jewellery* (London, 1961) [Higgins].

H. Hoffmann and P. F. Davidson, *Greek Gold; Jewelry from the Age of Alexander* (Boston, etc., 1965) [Hoffmann and Davidson].

H. Hoffmann, 'Sexual and asexual pursuit: a structuralist approach to Greek vase painting', *Royal Anthropological Institute of Great Britain and Ireland, Occasional Paper* xxxiv (1977) [Hoffmann].

A. M. Leskov, *Antiquities from the Eastern Crimea* (in Russian), (Kiev, 1970) [Leskov 1970].

A. M. Leskov, 'Die skythischen Kurgane. Die Erforschung der Hügelgräber Südrusslands', *Antike Welt* v, Sondernummer (1974) [Leskov 1974].

A. L[yutsenko], 'Excavations of tumuli in the locality assumed to be ancient Nymphaea', *Drevnosti Trudi Moskovskago Arheologicheskii Obshchestva* (Transactions of the Moscow Archaeological Society) ii (1870) 54-5 (in Russian) [Lyutsenko (Appendix II)].

A. Lyutsenko, Report to the President of the Imperial Archaeological Commission, 3rd April 1869. Manuscript (with appended list of drawings by the 'Painter Gross') in the Archive LOIIMK, Archaeological Commission file 1867g, No. 11,101 [Report (Appendix III)].

J. Mertens, 'A Hellenistic find in New York', *Metropolitan Museum Journal* xi (1976) 71-84 [Mertens].

E. H. Minns, *Scythians and Greeks* (Cambridge, 1913) [Minns].

G. M. A. Richter, *Engraved Gems of the Greeks and the Etruscans* (London, 1968) [Richter].

M. Rostovtzeff, *Iranians and Greeks in South Russia* (Oxford, 1922) [Rostovtzeff].

L. F. Silant'eva, 'Necropoleis at Nymphaeum', *Materialy i issledovaniya po arheologii SSSR* (Materials for Research on the Archaeology of the USSR) lxix (1959) 1-107 (in Russian) [Silant'eva].

B. A. Sparkes and L. Talcott, 'Black and Plain Pottery', *The Athenian Agora* xii (Princeton, N.J., 1970) [Agora xii].

T. Talbot Rice, *The Scythians* (London, 1957) [Talbot Rice].

G. L. Taylor and D. Scarisbrick, *Finger Rings from Ancient Egypt to the Present Day* (Oxford, 1978) *[Finger Rings]*.